Girlfriends

MQP

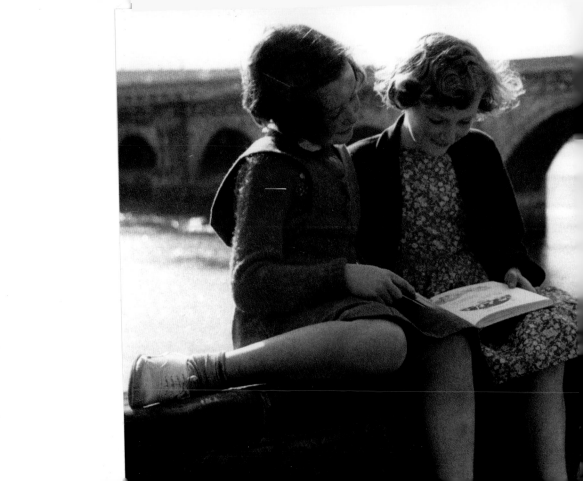

A friend is a poem.

Persian proverb

To like and dislike the same things, that is indeed true friendship.

Sallust

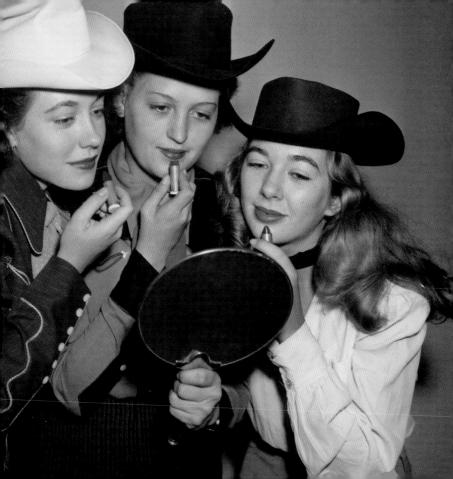

Together they were unconquerable.

Maeve Binchy

Treat your friends as you do your pictures, and place them in their best light.

Jennie Jerome Churchill

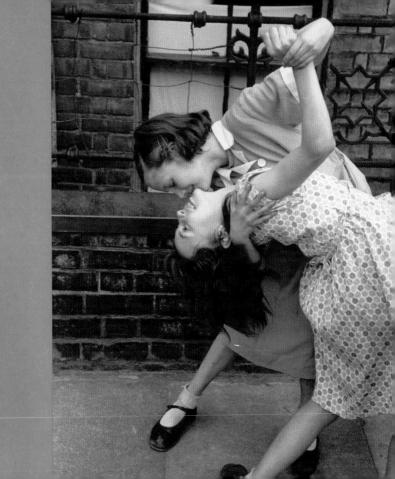

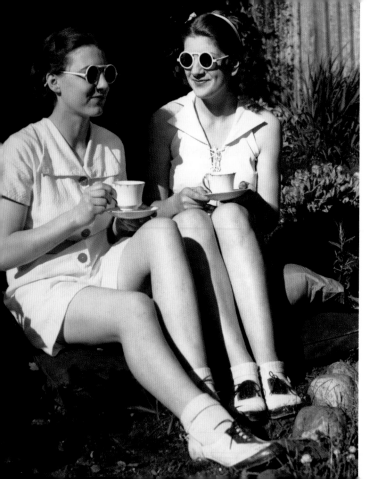

Friendship is a strong and habitual inclination in two persons to promote the good and happiness of one another.

Eustace Budgell

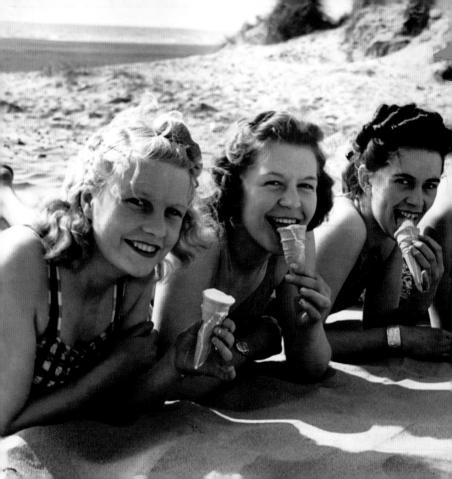

Girlfriend: keeper of secrets,
partner in crime,
cheerleader of mine.

Gena Dixon

Sweet is the scene where genial friendship plays
the pleasing game of interchanging praise.

Oliver Wendell Holmes

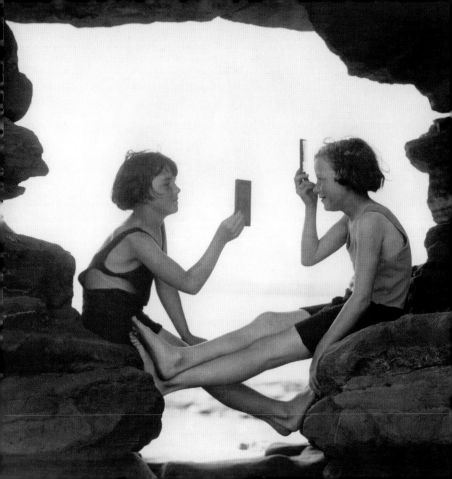

Why do people
lament their follies
for which their
friends adore them?

Gerard Hopkins

The companions of our childhood always possess a certain power over our minds which hardly any later friend can obtain.

Mary Shelley

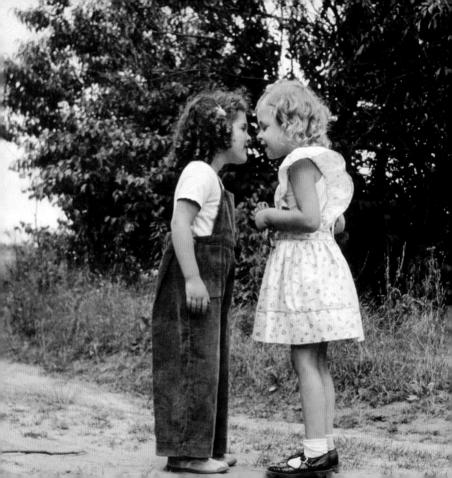

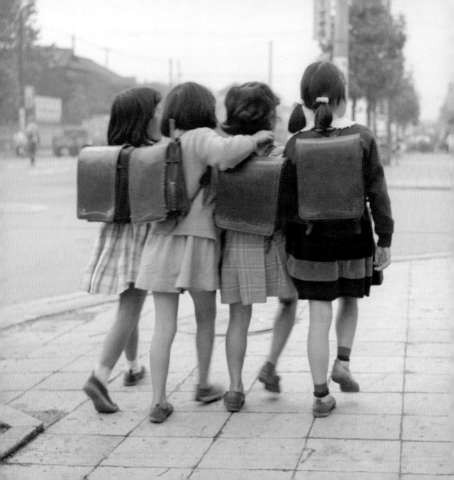

There's no friend like someone who has known you since you were five.

Anne Stevenson

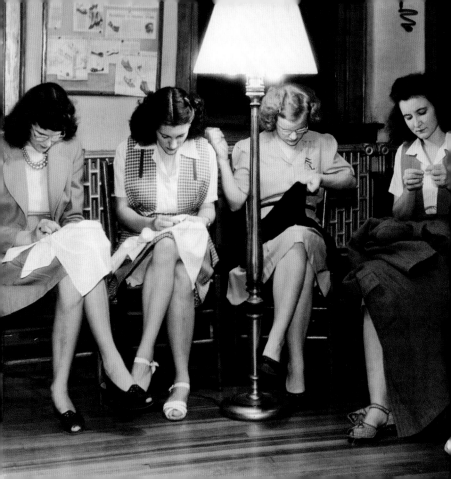

Constant use had not
worn ragged the fabric
of their friendship.

Dorothy Parker

In reality, we are still children.
We want to find a playmate
for our thoughts and feelings.

Dr. Wilhelm Stekel

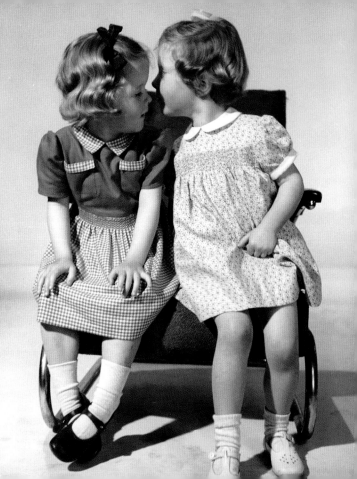

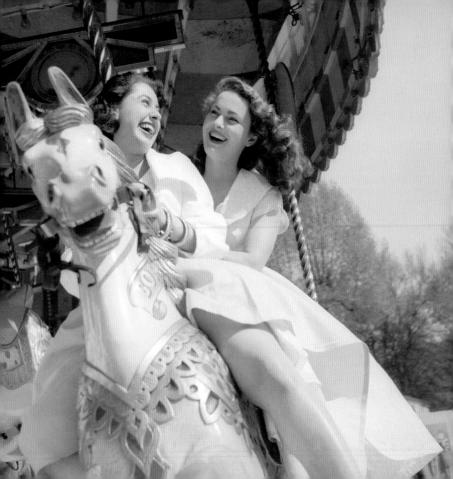

Girls together sharing pleasures that girls will.

Thadious M. Davis

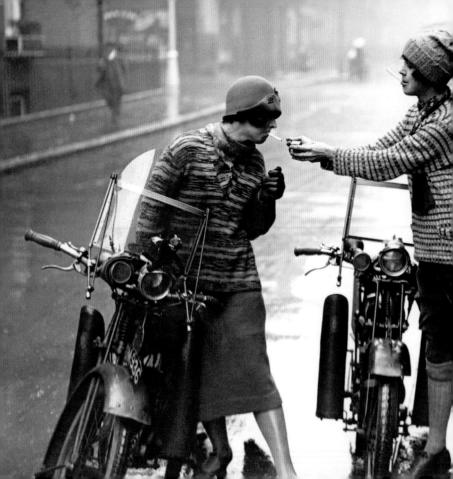

Good girls go to heaven,
bad girls go everywhere.

Anonymous

31

A faithful friend is a sturdy shelter.

Bible, King James version

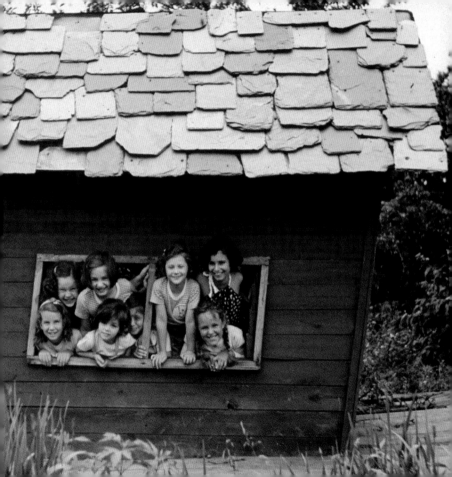

Friendship is a word the very
sight of which in print makes
the heart warm.

Augustine Birrell

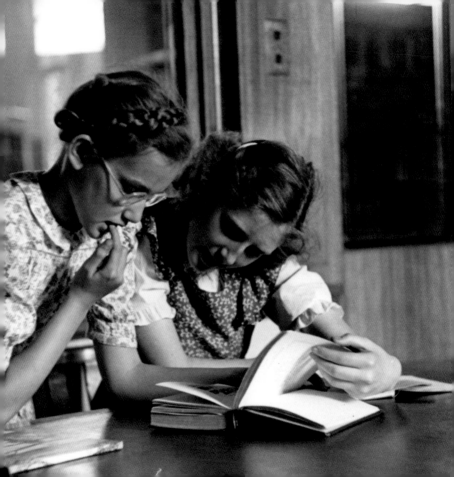

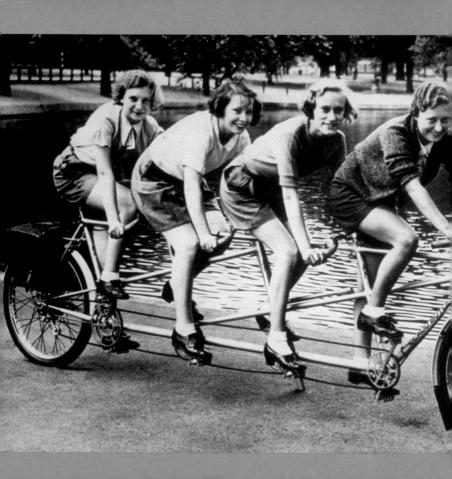

With friends all things
are in common.

Cicero

There was a definite process
by which one made people
into friends, and it involved
talking to them and listening
to them for hours at a time.

Rebecca West

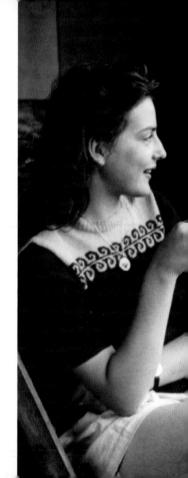

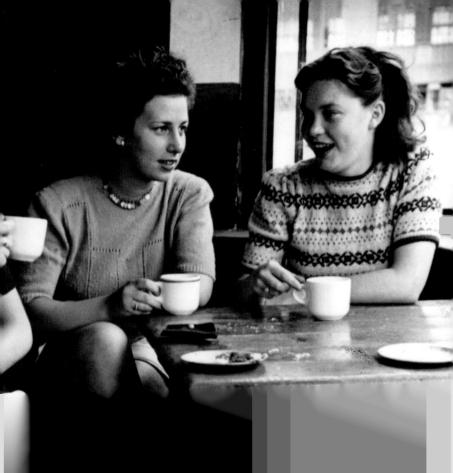

Silences make the real conversations between friends. Not the saying but the never needing to say is what counts.

Margaret Lee Runbeck

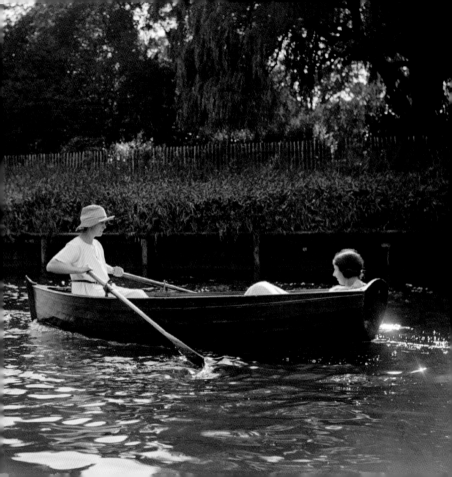

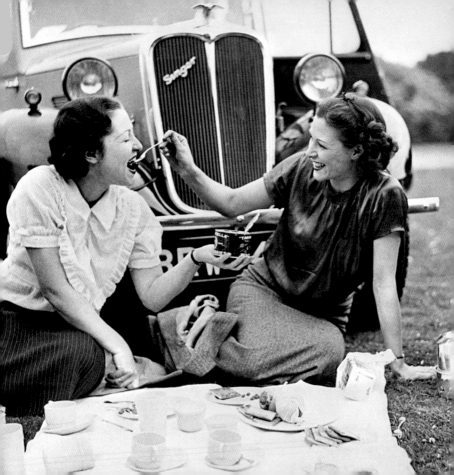

Friendship is the
bread of the heart.

Mary Russell Mitford

43

In real friendship
the judgement, the
genius ... of each
party become the
common property
of both.

Maria Edgeworth

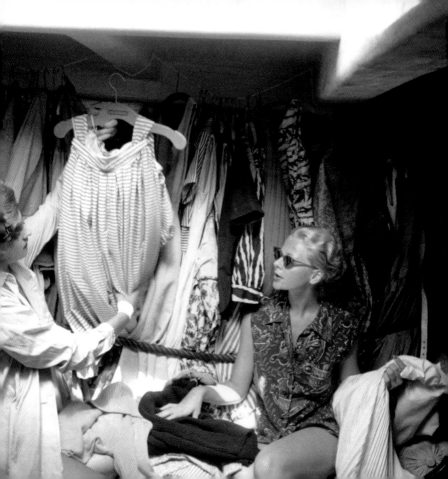

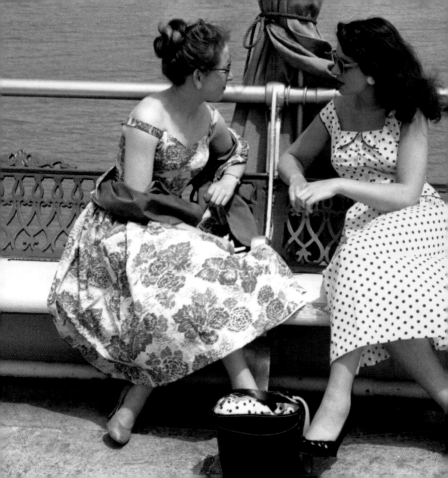

And we find at the end
of a perfect day,
the soul of a friend
we've made.

Carrie Jacobs Bond

The ideal friendship is to feel as
one while remaining two.

Anne Sophie Swetchine

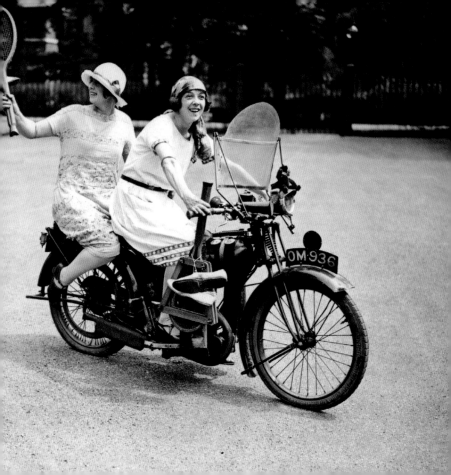

The endearing elegance
of female friendship.

Samuel Johnson

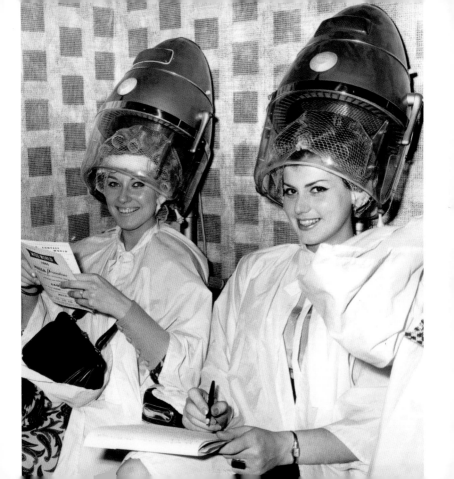

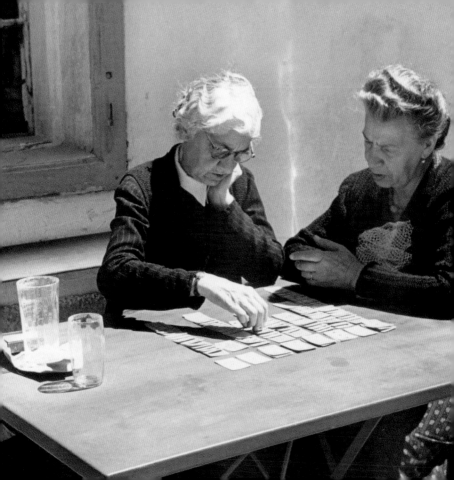

Friend, what years
could us divide?

Dinah Mulock Craik

Even reckonings keep
long friends.

Thomas Fuller

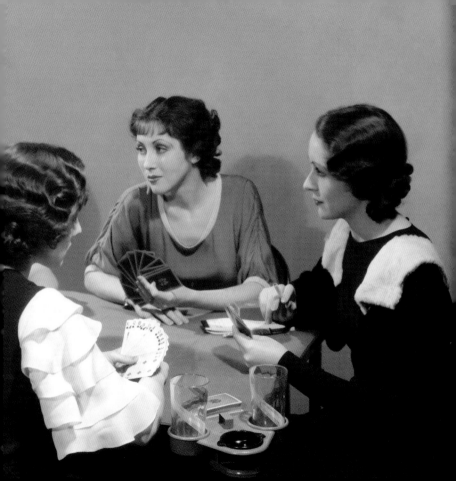

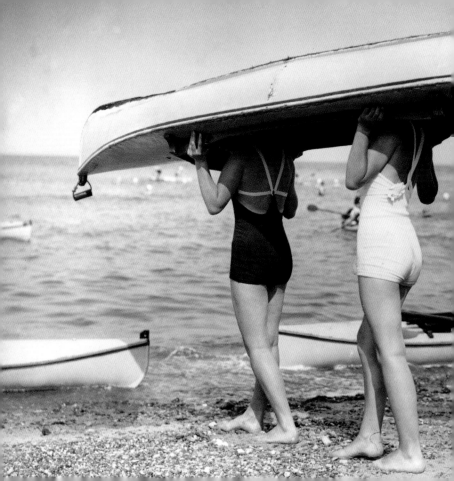

We have been friends together in sunshine and in shade.

Caroline Sheridan Norton

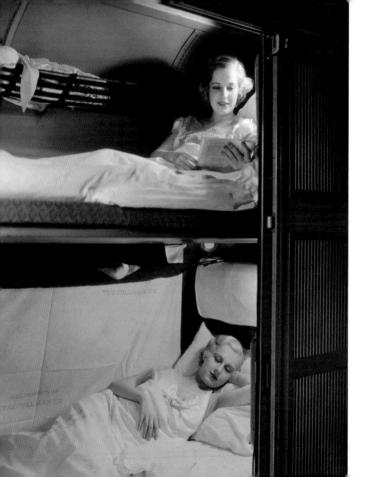

We have slept together,
Rose at an instant, learn'd, play'd, eat together;
And wheresoe'er we went, like Juno's swans;
Still we went coupled and inseparable.

William Shakespeare

I want someone to
laugh with me.

Robert Burns

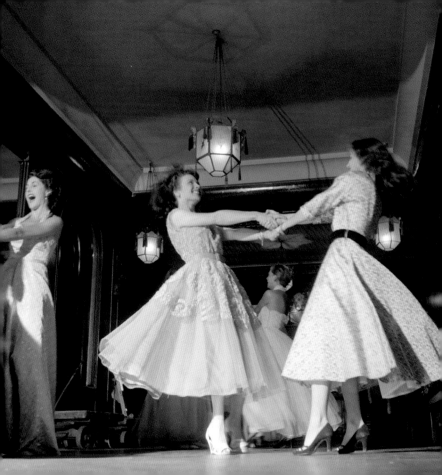

Instead of herds of oxen, endeavor to assemble flocks of friends about your house.

Epictetus

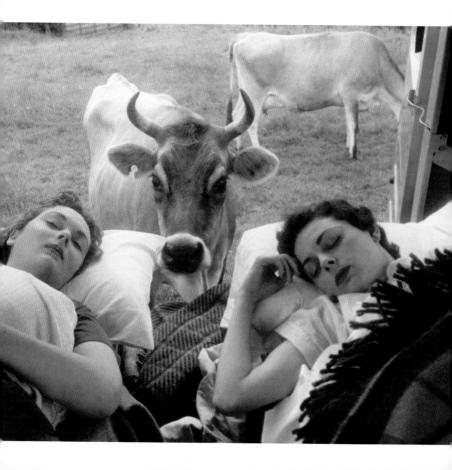

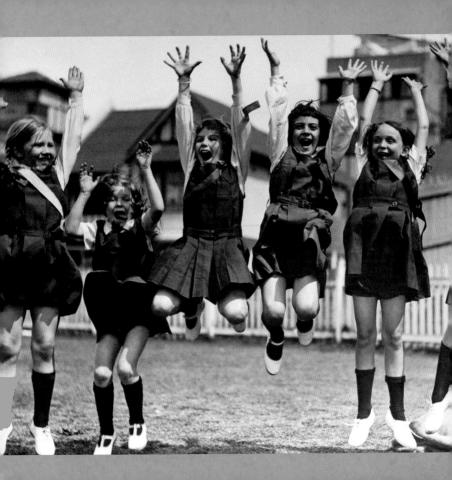

Each friend represents a world in us, a world not born until they arrive, and it is only by this meeting that a new world is born.

Anaïs Nin

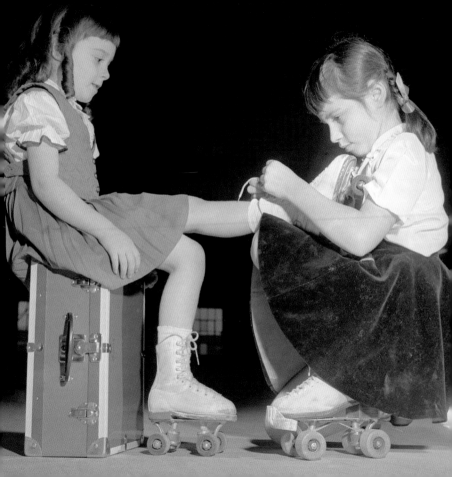

Best friends
can help untie
life's little knots.

Céline Dixon

We take a pleasure in viewing the picture of a friend.

David Hume

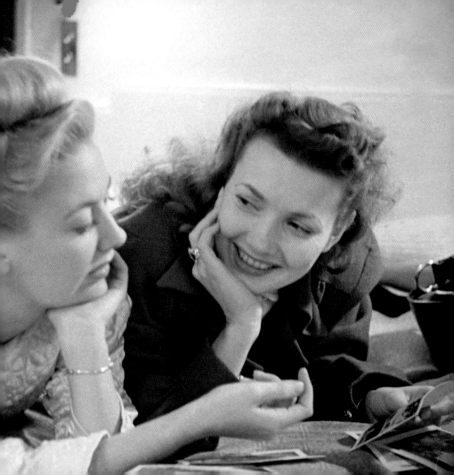

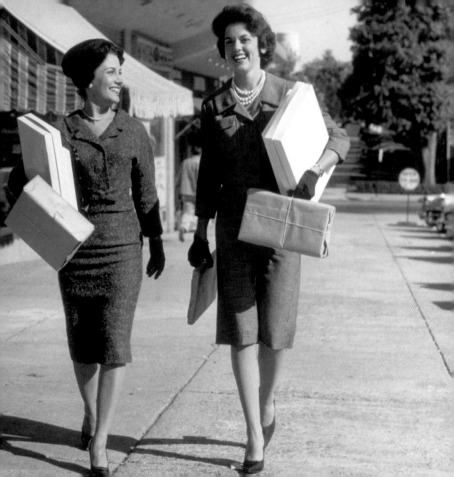

Nothing can be
purchased which is
better than a firm friend.

Tacitus

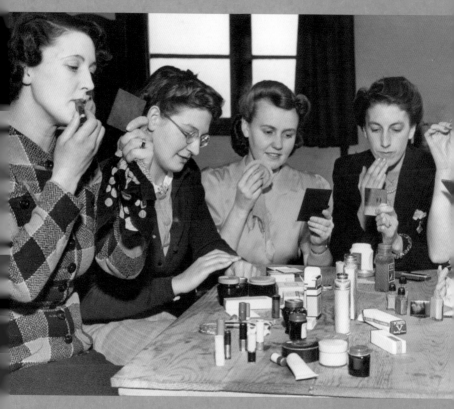

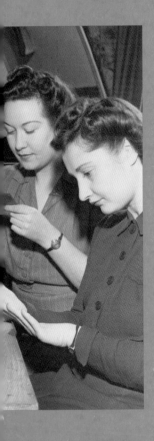

Female friendships that work
are relationships in which
women help each other to
belong to themselves.

Louise Bernikow

No friendship is so cordial or so delicious as that of girl for girl.

Walter Savage Landor

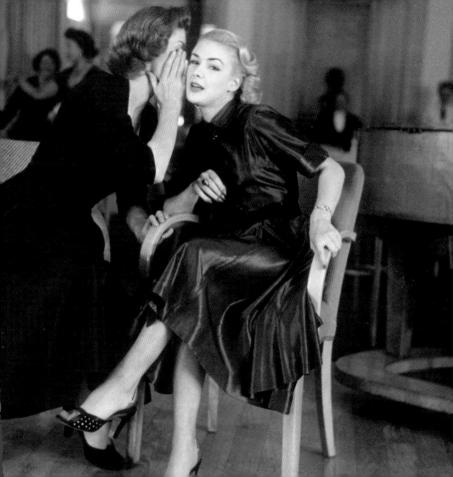

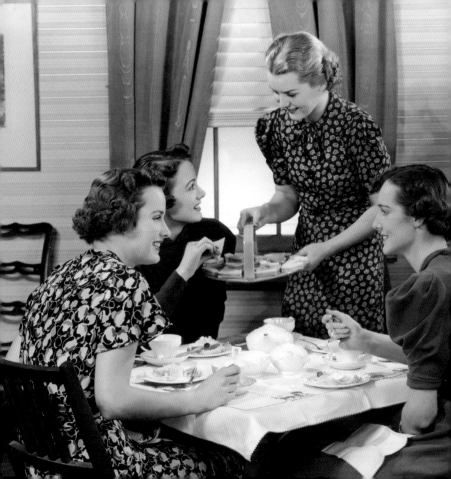

To find out a girl's faults, praise her to her girlfriends.

Benjamin Franklin

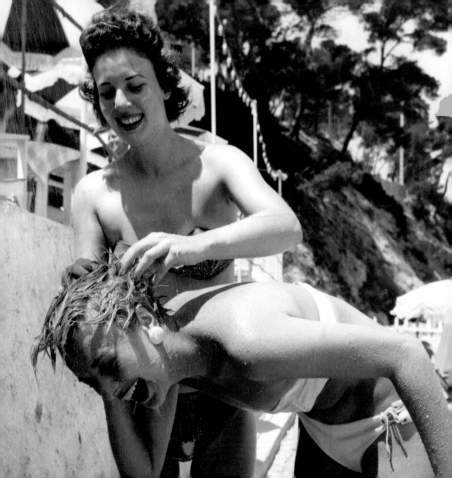

True friends are those who really know you but love you anyway.

Edna Buchanan

When adversities flow, then love ebbs; but friendship standeth stiffly in storms.

John Lyly

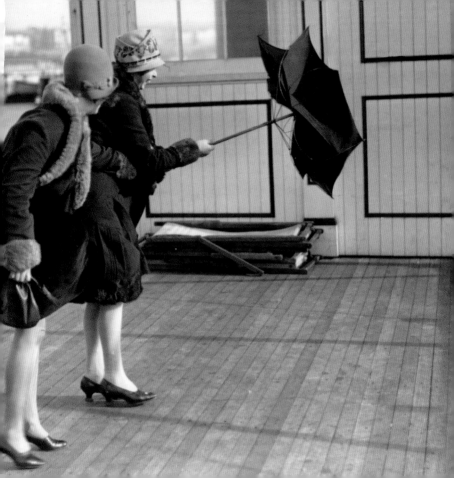

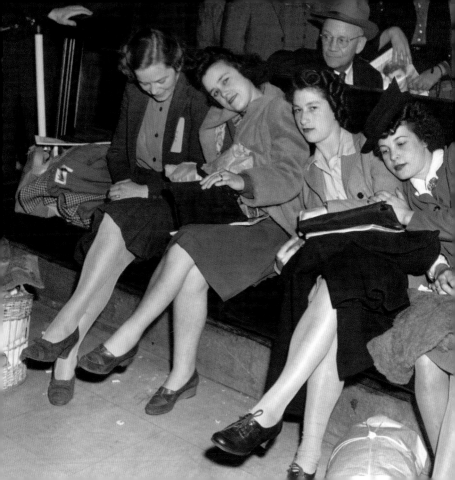

To be a strong hand in the dark
to another in a time of need.

Hugo Black

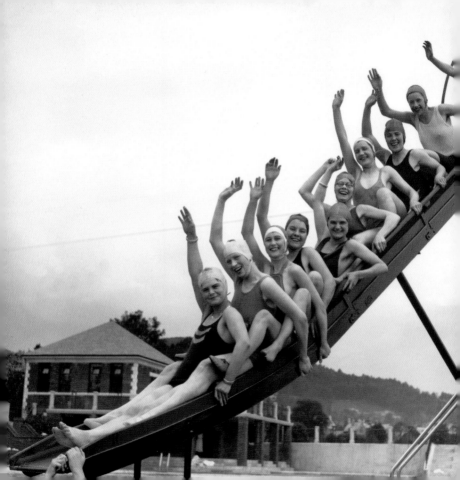

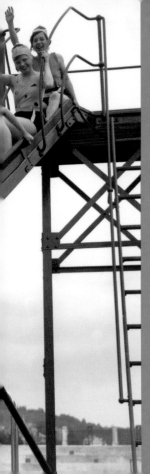

Fellowship in joy ... is
what makes friends.

Nietzsche

However deep our devotion may be to parents ... it is our contemporaries alone with whom understanding is instinctive and entire.

Vera Brittain

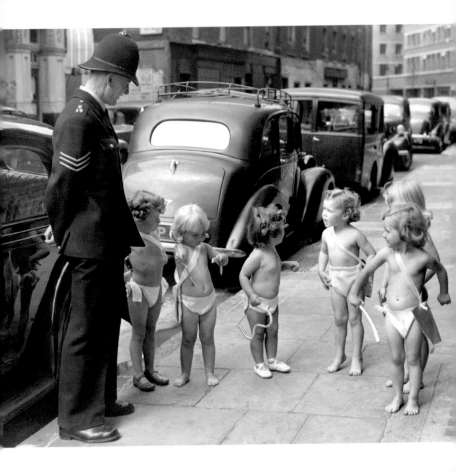

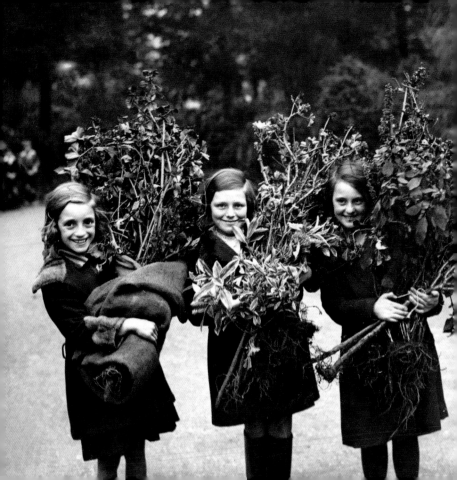

Friendship is a sheltering tree.

Samuel Taylor Coleridge

Friendship is not to be bought at a fair.

Thomas Fuller

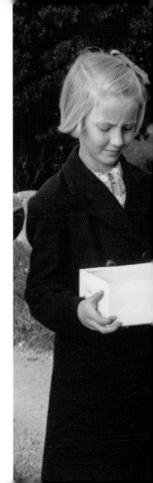

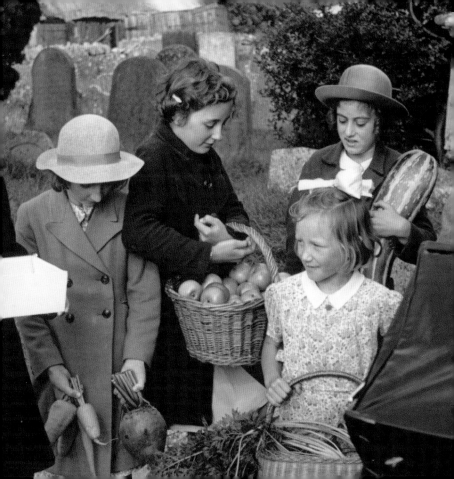

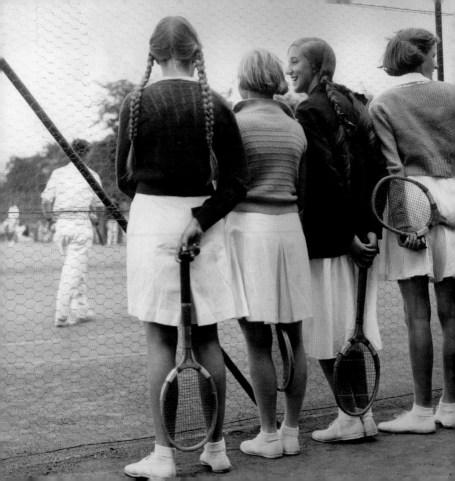

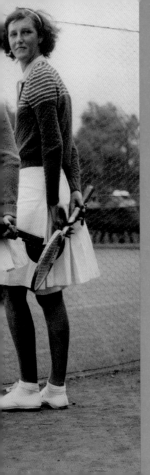

What a friend gets is
not lost.

Irish proverb

Books and friends
should be few but good.

Proverb

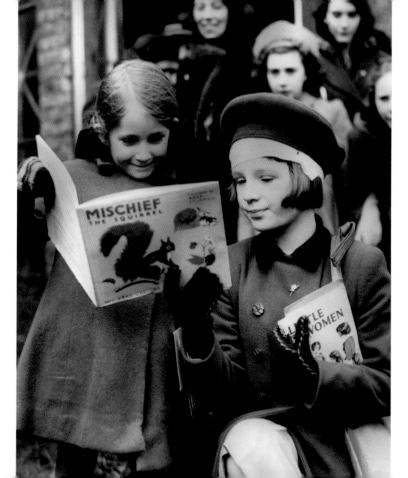

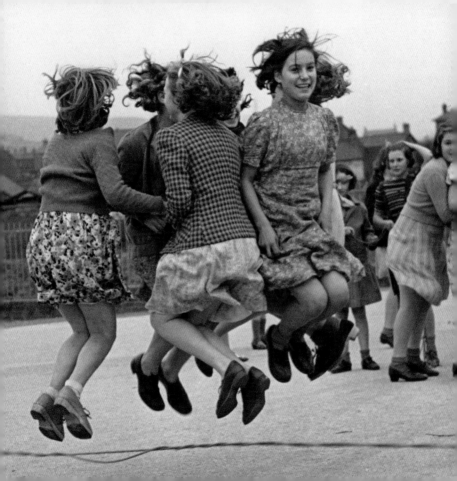

Friendship … has heights unknown to love.

Mariama Bâ

A friend is worth all the hazards we can run.

Edward Young

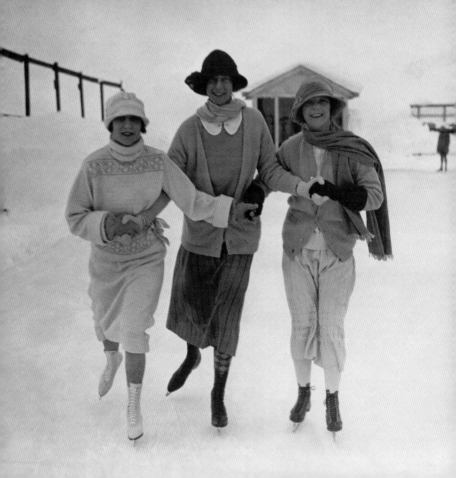

The essence of true friendship
is to make allowance for each
other's little lapses.

David Storey

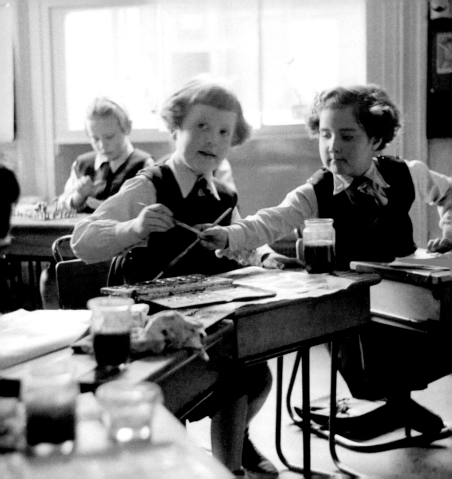

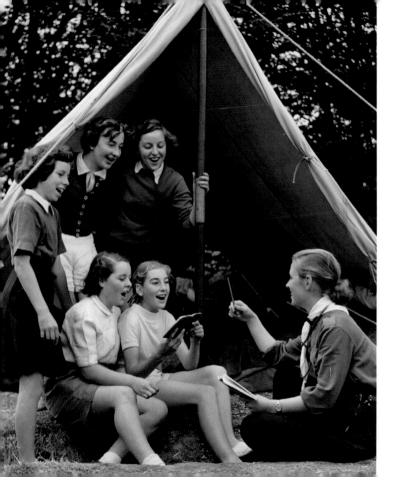

Thank God for a trusty chum!

Rudyard Kipling

You can make more friends in two months by becoming interested in other people than you can in two years by trying to get other people interested in you.

Dale Carnegie

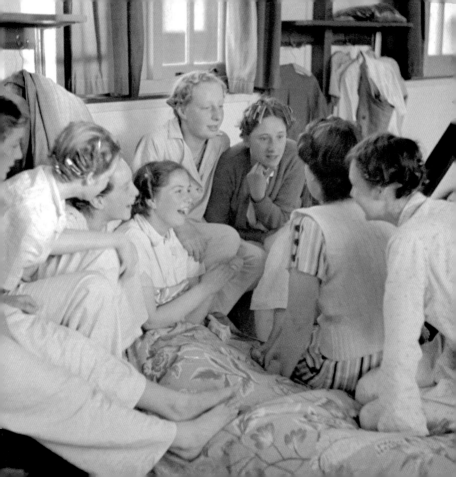

Ah, how good it feels! The hand of an old friend.

Henry Wadsworth Longfellow

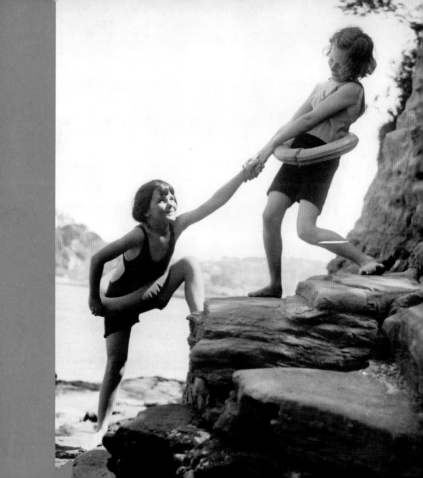

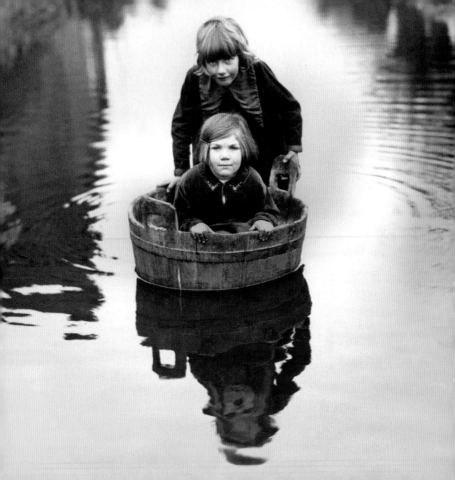